Copyright © 2016 Bonnie Brenton / Stress Relief Adult Coloring. All Rights Reserved. No part of this publication may be reproduced, distributed, or transmitted in any form or by any means, including photocopying, recording, or other electronic or mechanical methods, without the prior written permission of the publisher, except in the case of brief quotations embodied in critical reviews and certain other non-commercial uses permitted by copyright law.

Thank you for your recent purchase of ***Thanksgiving Coloring Cards.*** Inside you will discover 20 beautiful fall designs that are perfect to color and share. Help spread the spirit of this beautiful holiday with your loved ones. Happy coloring!

With love,

Bonnie

Thanksgiving Coloring Cards
Cards to Color and Share this Fall

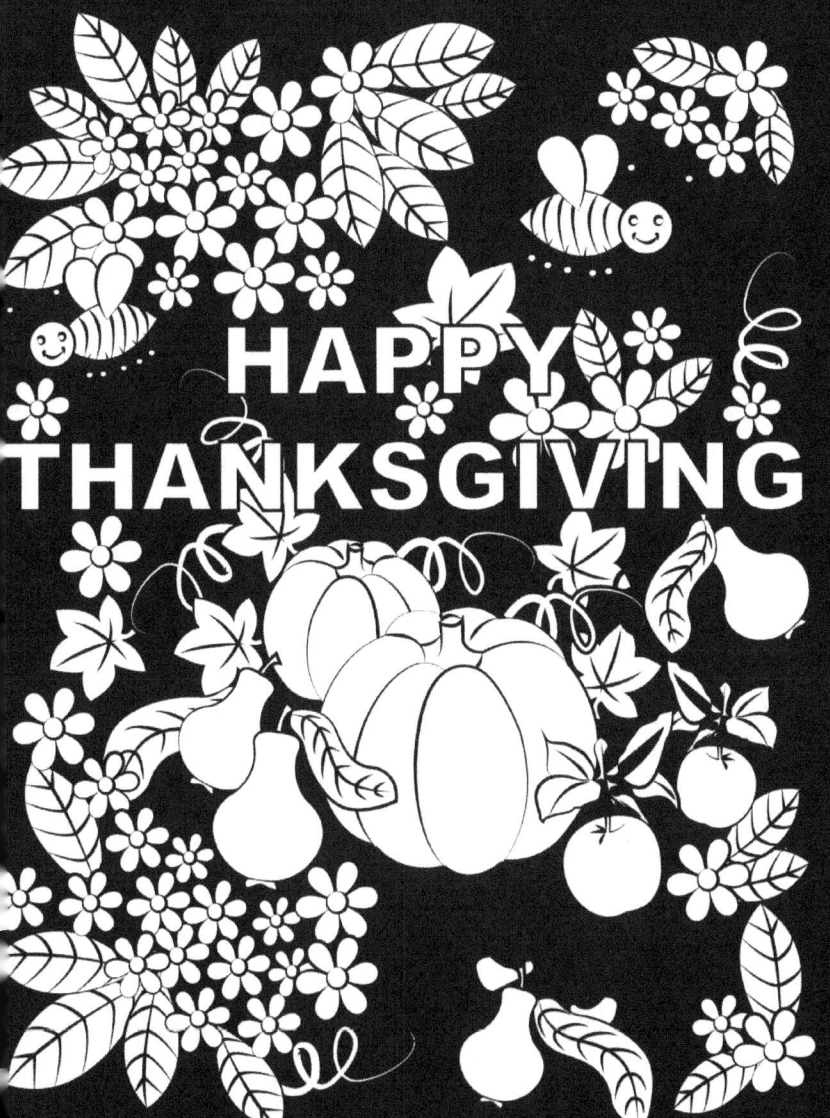

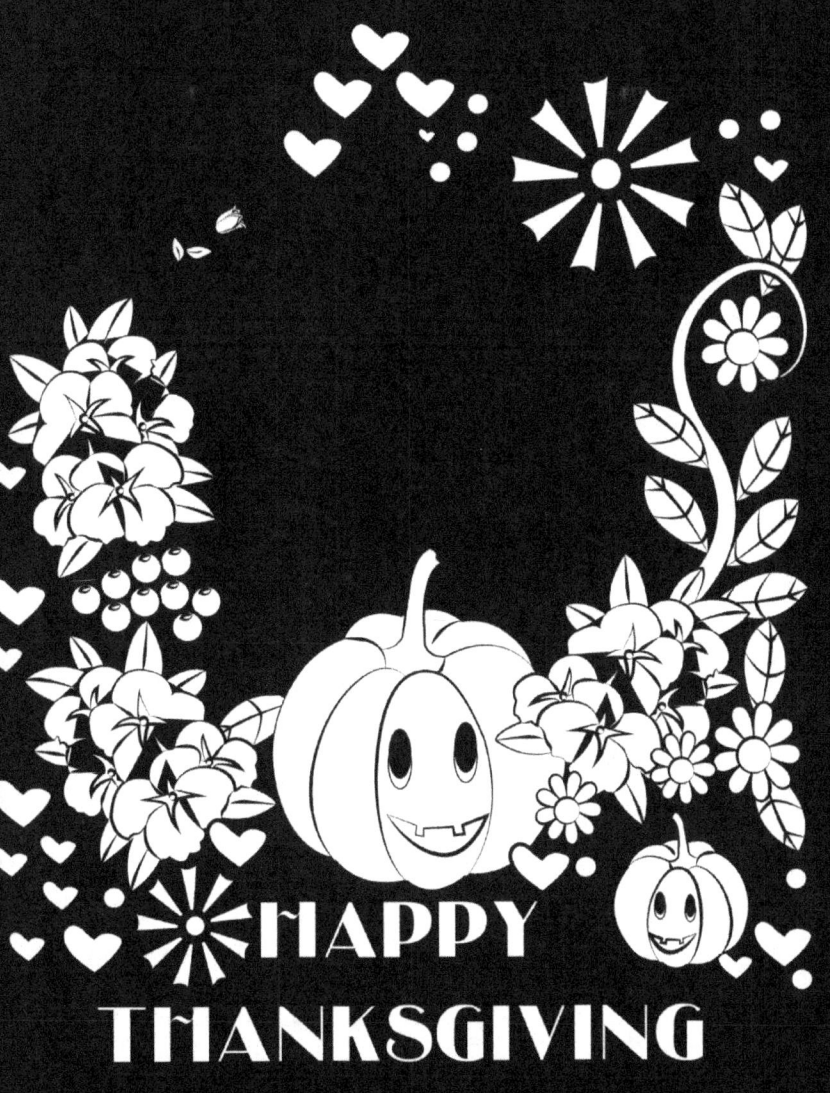

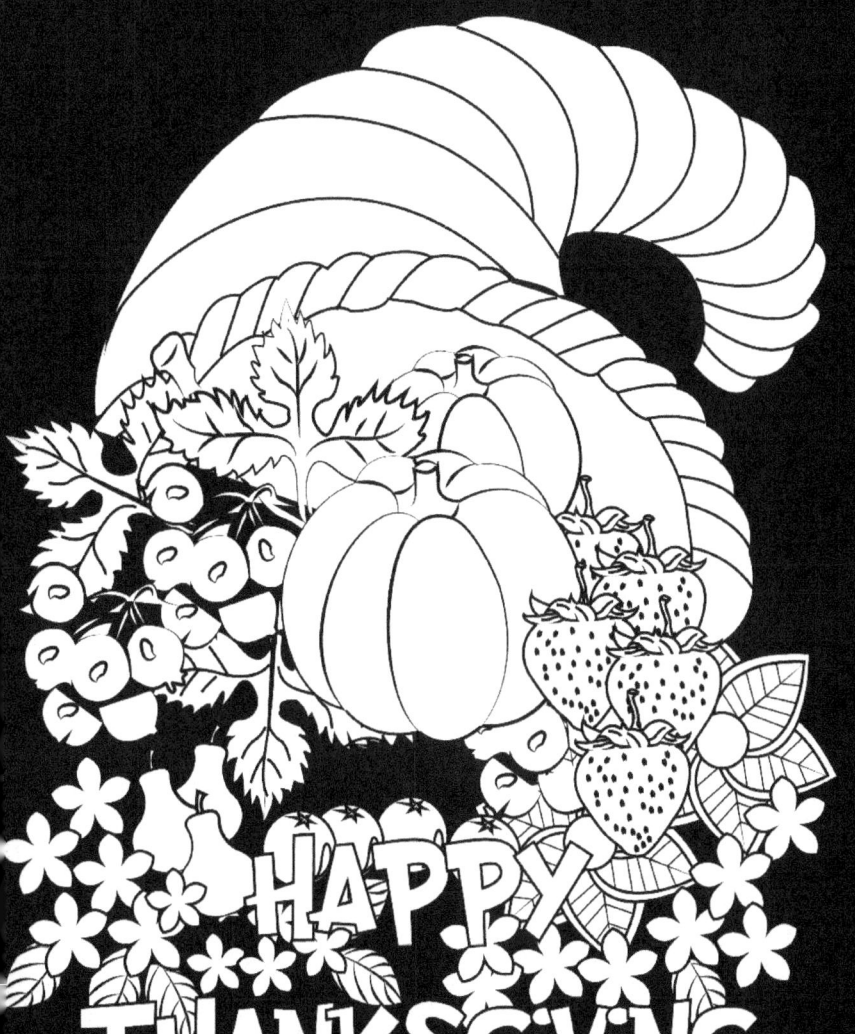

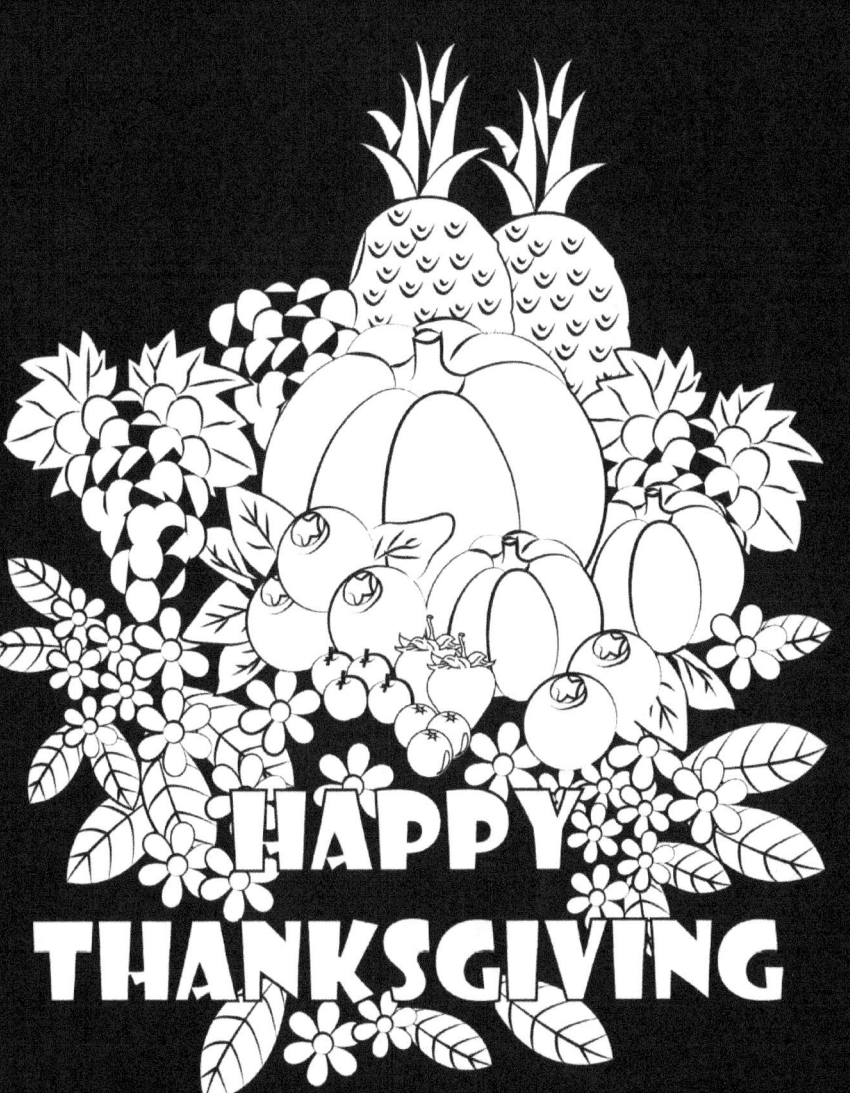

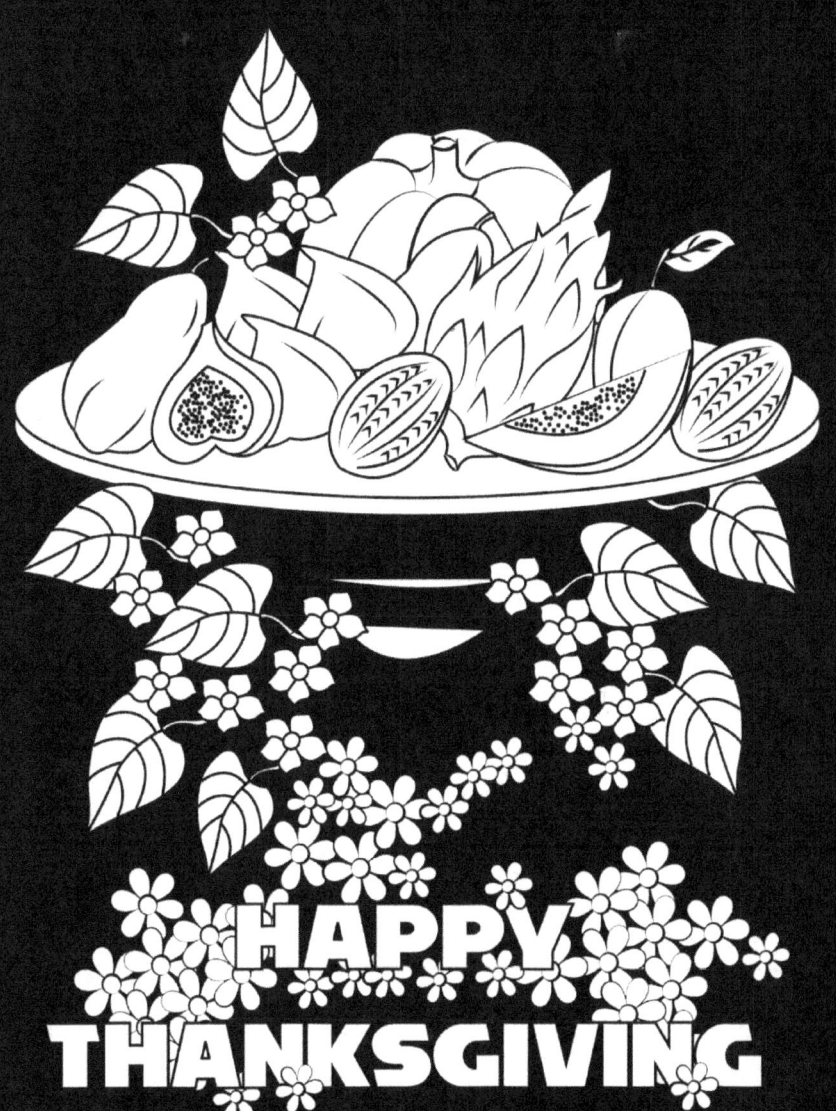

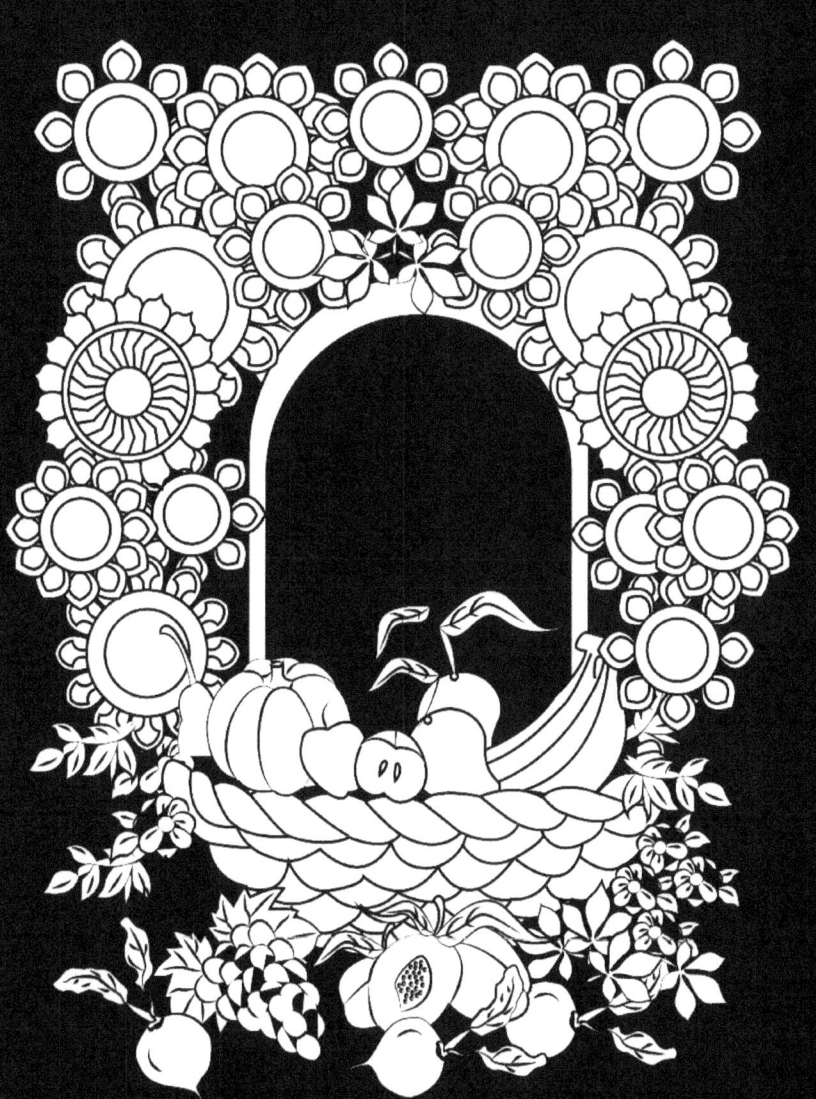

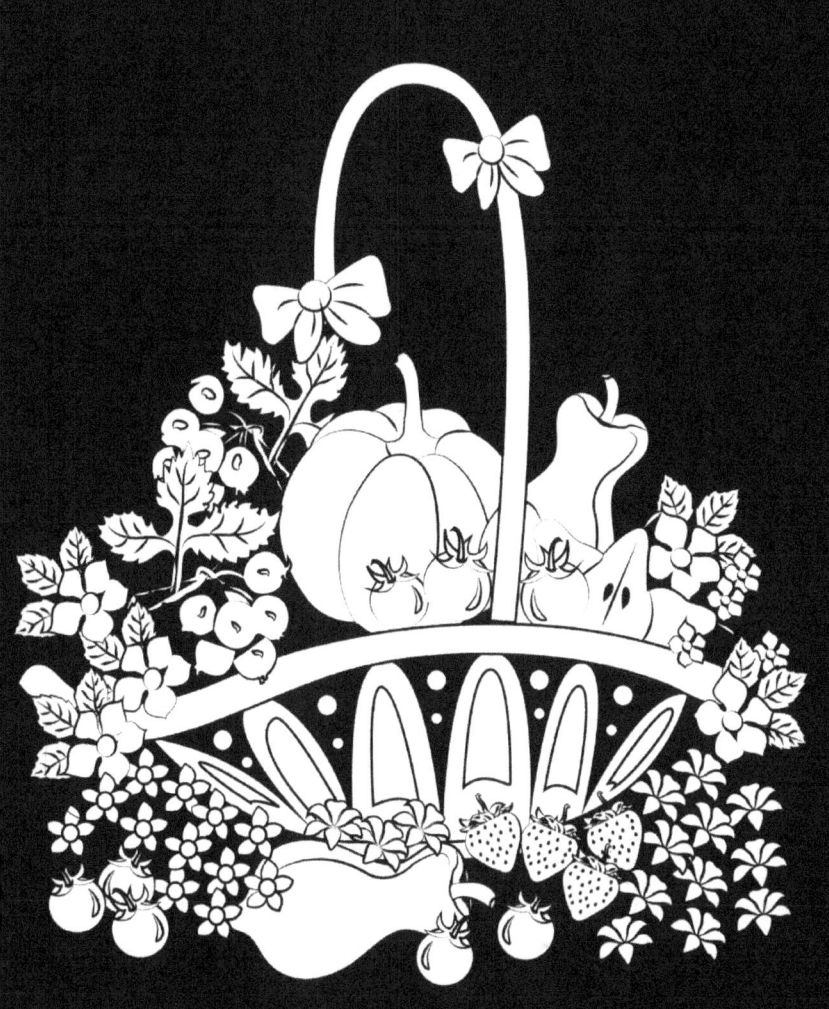

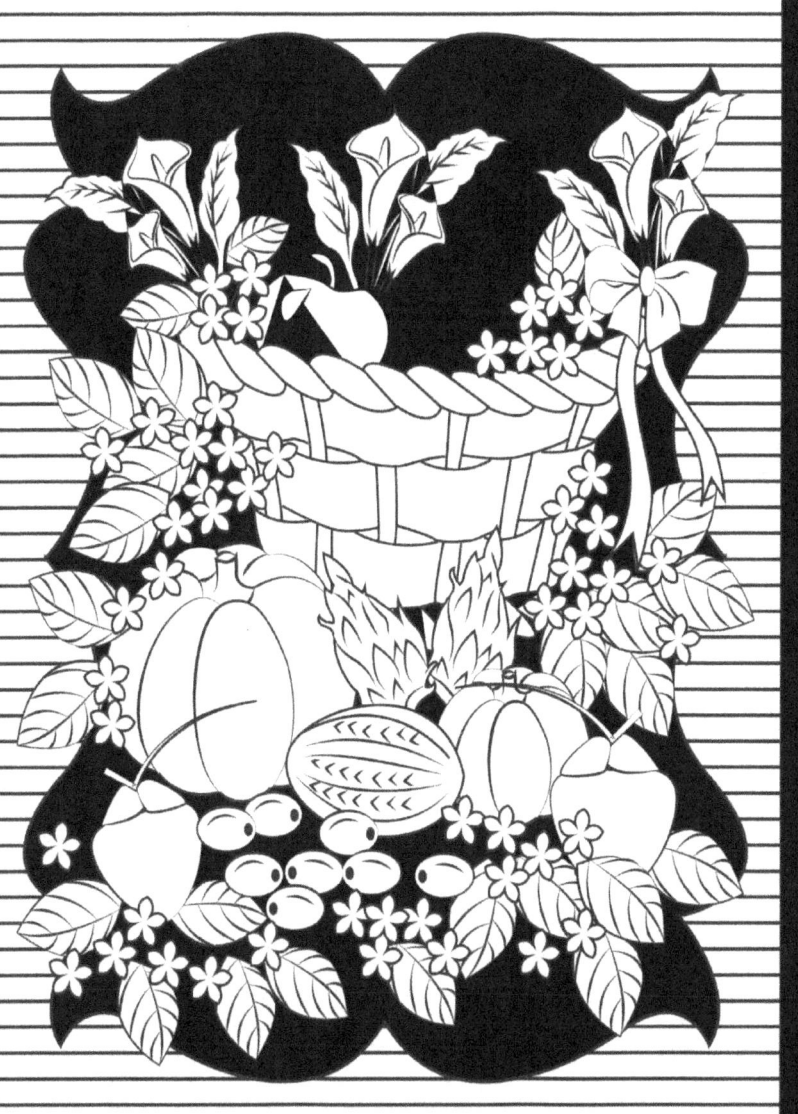

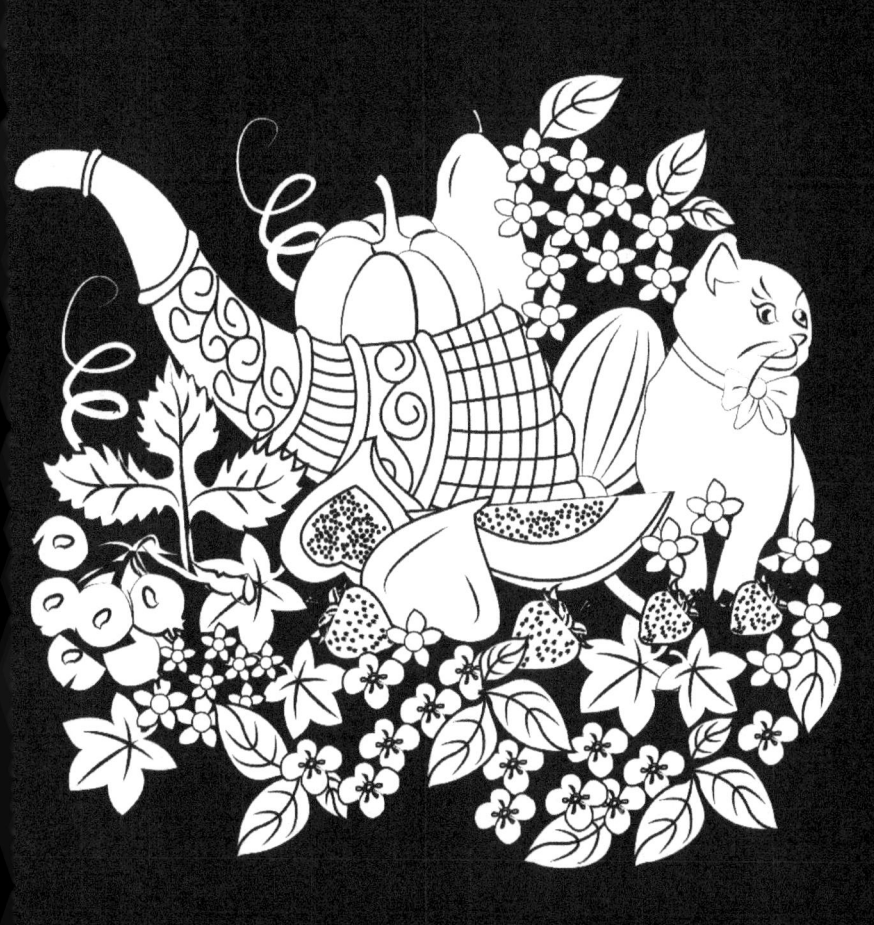

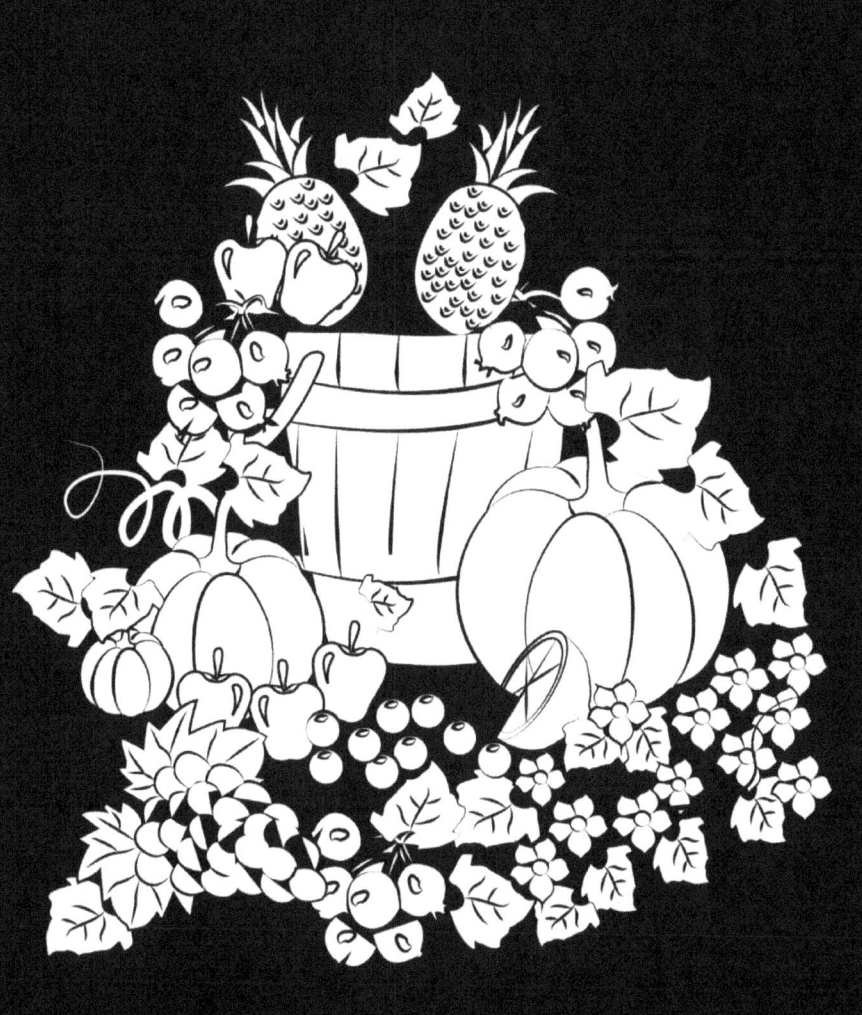

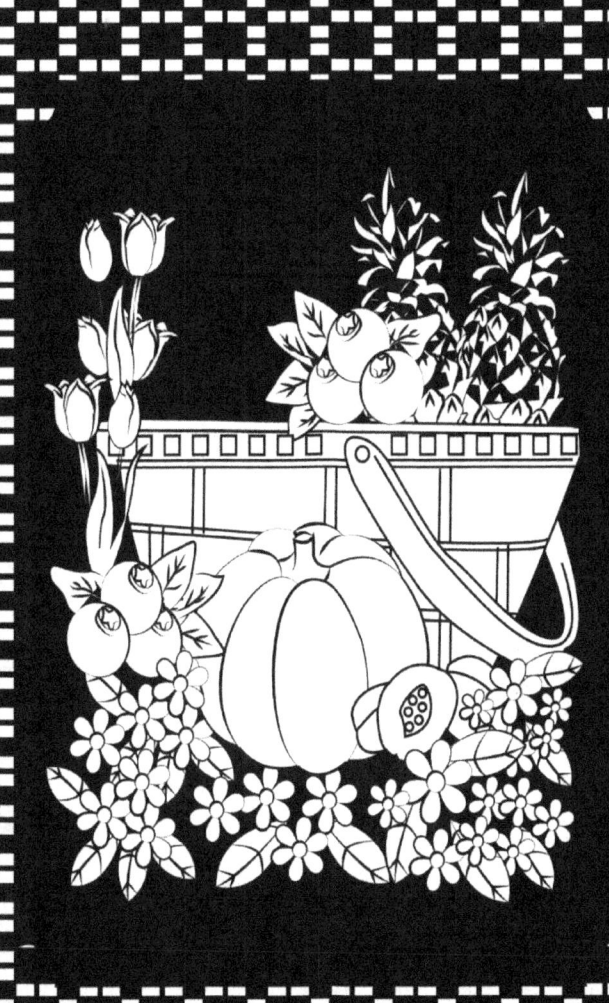

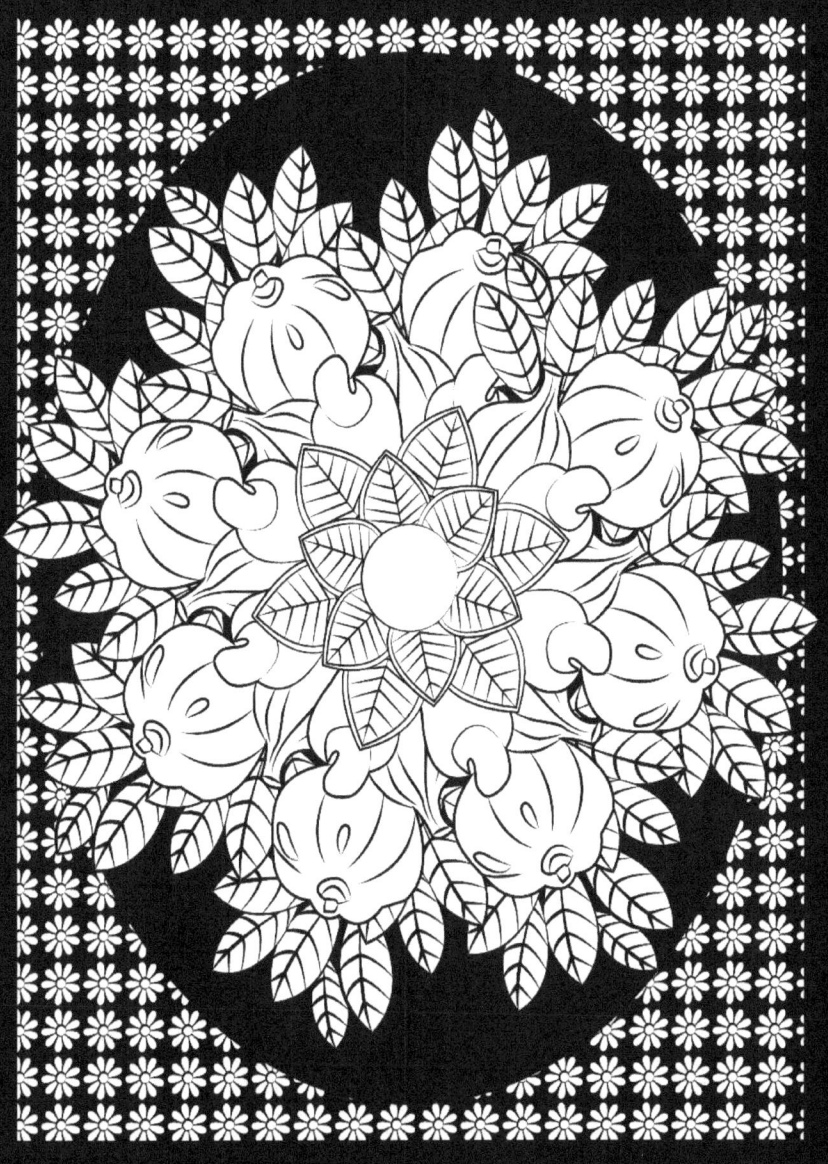

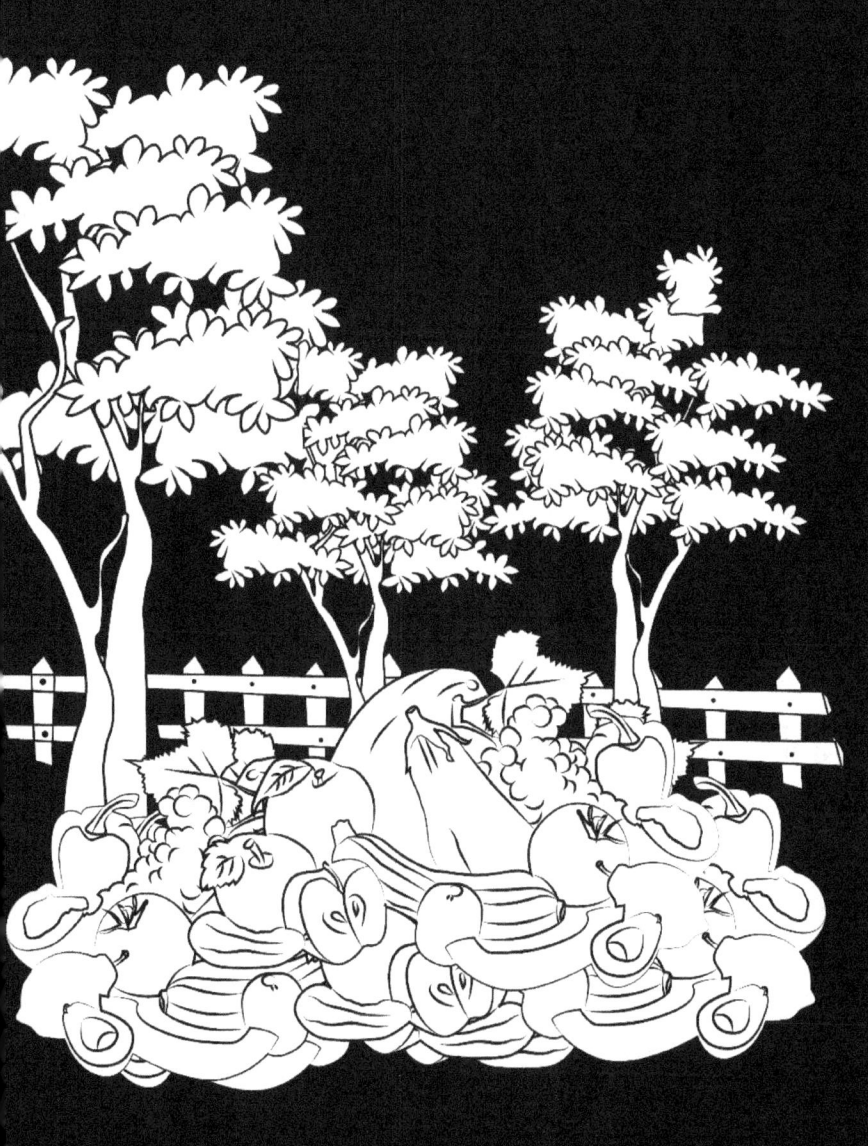

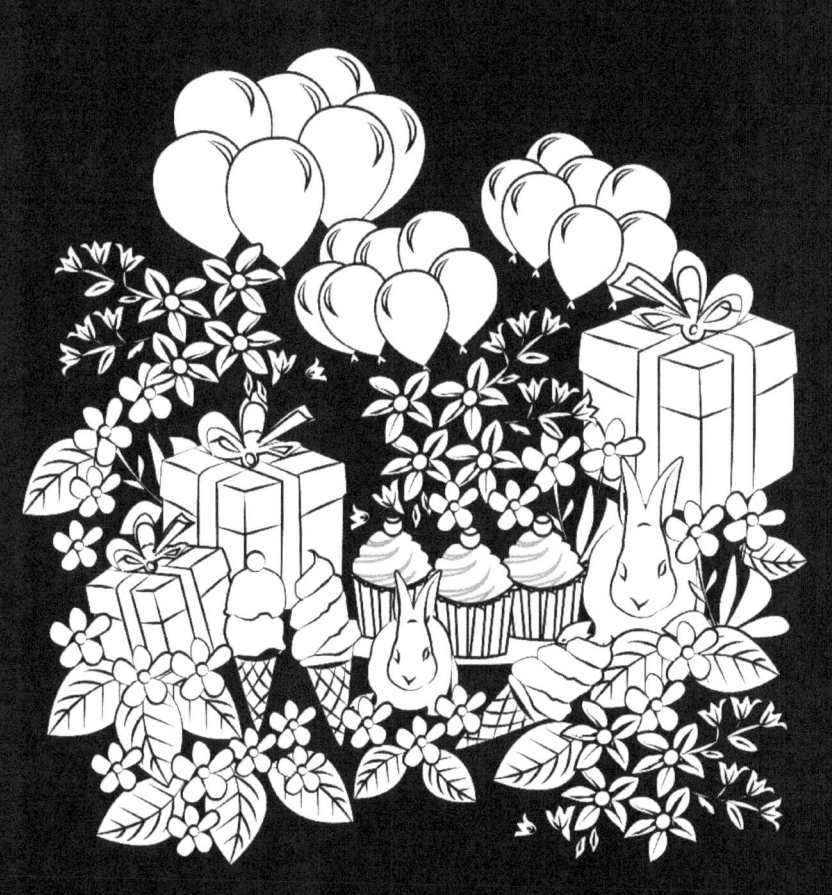

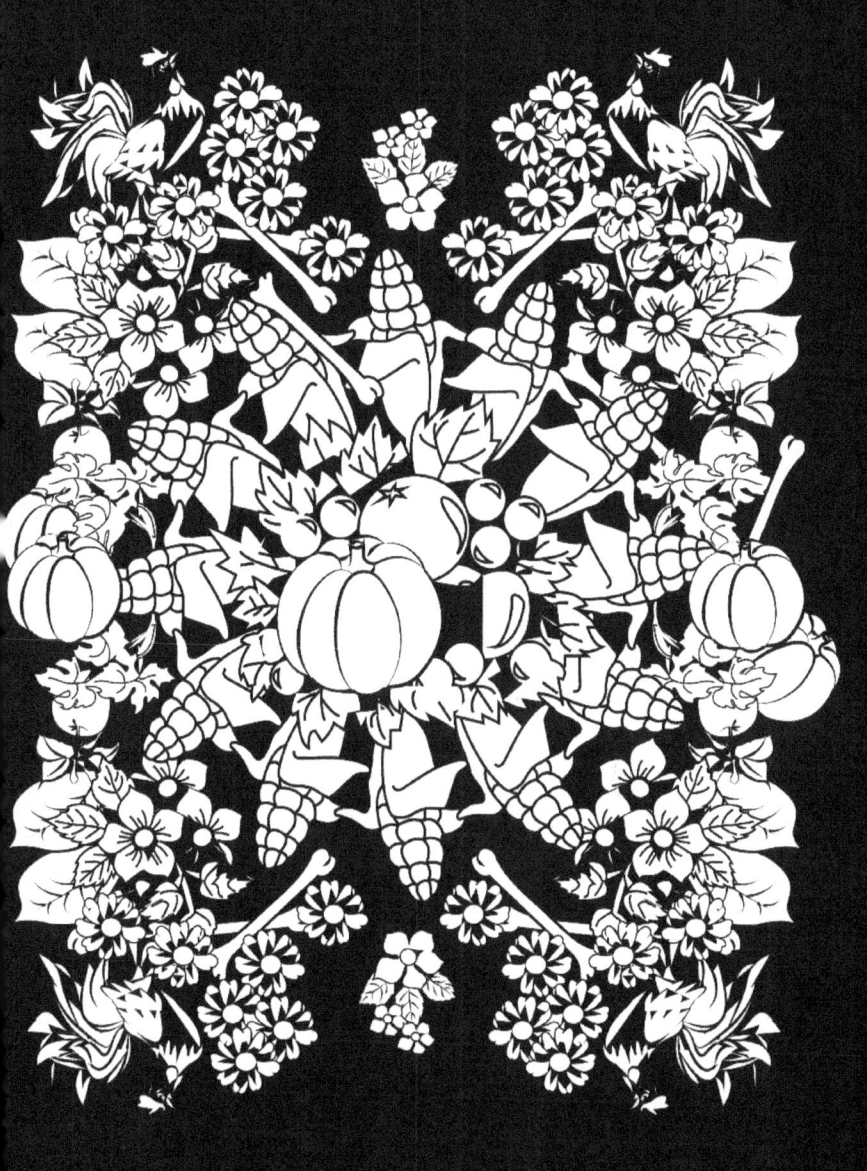

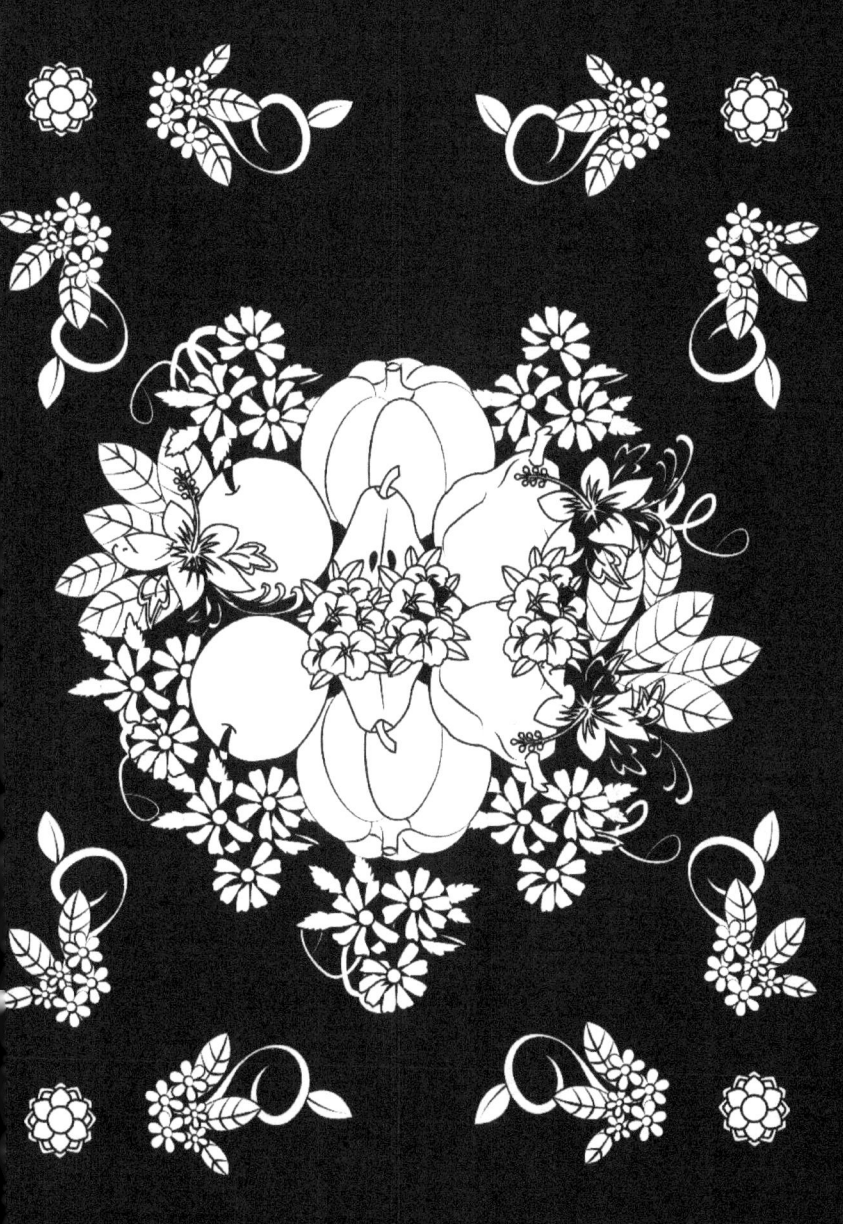

www.ingramcontent.com/pod-product-compliance
Lightning Source LLC
Chambersburg PA
CBHW061231180526
45170CB00003B/1241